Henry Moore

Pat Gilmour

HENRY MOORE
graphics in the making

Tate Gallery 1975

This book was published to celebrate a major gift from Henry Moore
to the new Tate Gallery Print Department. The works discussed
include trial proofs and states which illuminate selected images from
his gift.

Exclusively distributed in France and Italy by Idea Books
24 Rue du 4 Septembre, 75002 Paris and Via Cappuccio 21, 20123 Milan

ISBN 0 900874 92 9 paper
Published by order of the Trustees 1975
for the exhibition of 21 May – 6 July 1975
copyright © 1975 The Tate Gallery
Designed and published by the Tate Gallery Publications Department,
Millbank, London SW1P 4RG
Printed in Great Britain by The Westerham Press Ltd, Westerham, Kent

Contents

Cover
Woman Holding Cat, 1949
Catalogue No. 11

Foreword

Although as yet little has been seen of the new Print Department by visitors to the Tate, a great deal of work has been going on below stairs. In encouraging the Institute of Contemporary Prints to accept generous gifts both individually from artists and in the form of great collections from Chris Prater and Curwen Studio, we have always had in mind a series of print exhibitions which would demonstrate the important part that the print has played in the work of so many of Britain's leading artists.

This first exhibition celebrates the outstandingly generous gift by Henry Moore of a complete set of his prints to the Tate – a gift which was the result of an initiative by Stewart Mason, Curator of the Institute of Contemporary Prints. Drawings and printed work will be shown together so that the recurrent themes can be seen in their relationship to sculpture in the Gallery's permanent collection.

It is particularly interesting to be able to show preparatory states of the etchings and progressive proofs of lithographs which give insight into the working method of the artist. None of these has been shown before and the latest lithographic portfolio of *Helmet Heads* is shown for the first time in London.

Norman Reid, Director

Moore's graphic art

At the beginning of this year, the only prints by Henry Moore to which the Tate's new Print Department could have laid claim were those gifted to the Gallery via the Institute of Contemporary Prints by the Curwen Lithography Studio. With one generous gesture, Henry Moore has given the Tate a completed archive of his graphic work, which includes the immensely important recent portfolios such as the *Elephant Skull* etchings and the *Stonehenge* lithographs, and lacks only those occasional images where an artist's proof is no longer available.

Since there have already been books and exhibitions covering the major portfolios, it was decided not simply to expose these again, but to try to give some insight into Moore's working methods by displaying loaned preparatory drawings and states, never before seen, for certain selected images. In painting and drawing, the 'pentimenti', or marks revealing alterations made during the act of painting, can only be detected laboriously afterwards. In printmaking, if the states are kept, they provide fascinating evidence of the way in which an idea may have been developed, or the formal quality of the work changed. At the same time, it was hoped that in a very small way, the Print Department could relate the graphic art to some of Henry Moore's sculpture in the permanent collection, as an intimation of its ambition for a series of exhibitions. For it is a fact that in the past, the majority of Print Departments have existed in a vacuum – specialised oases for the initiated within the great museums of the world. There, conservation demands that a man's printed work should be shut away in boxes in the dark, and the demarcations of art history have rendered it unlikely – even in a monograph, never mind on the wall – that we should ever see the painting and etching of an artist such as Rembrandt as a continuum. By adding contemporary graphic art to its interests, the Tate Gallery at least makes such future integration theoretically possible.

Although the prints were chosen chiefly where they provided a fascinating progression between the first sketch and the finished state, or a compelling visual correspondence between a graphic and a sculptural idea, by chance rather than design, they span the whole period in which Moore has been printmaking, and thus chart his increasing involvement in graphic activity.

There is no doubt that in the majority of his early prints – perhaps a third of his total output of around 300 images – Moore viewed printmaking as an activity subservient to drawing. 'After all, sculpture was what I was really interested in', he said, 'and I only had spasms of printmaking'.

Until the 1960s, the ideas for his printed work can usually be traced to drawings not created with the print in mind, but made sometimes several years before. These were never slavishly adhered to and frequently items from several different sources are amalgamated in a new graphic encounter in the final print; it must also be said that drawing, which scarcely features in the work of some sculptors, had an enormously important role for Moore at this time, being used to generate ideas for his sculpture.

An early exception to the generalisation above is the *Spanish Prisoner* of 1939, Moore's first lithograph. A deeply-felt emotional reaction to political events, the lithograph did proceed from a drawing especially made for it – a drawing which, prefiguring the internal/external *Helmet Head* ideas had tremendous ramifications in his sculpture. One may point to this as the kernel of future developments, just as one may see in Picasso's prints *The Minotauromachy*, or the *Dream and Lie of Franco* (a copy of which Moore owns) some of the symbols adapted for *Guernica*.

If war had not intervened, with its inevitable setbacks for print publishing, this experiment might well have been followed by others. As it was, apart from a solitary introduction to etch-

ing, it was ten years before Moore returned to graphics with the entirely innovatory and adventurous (yet also short-lived) adaptation of collotype.

This adaptation, which was named collograph to distinguish it from reproductive process, involved the autographic drawing of photopositives created specifically for transfer to the printing surface by light. Such autographic transparencies were also used lithographically by the printers W.S. Cowell of Ipswich, with whom Moore worked on several commissions for School Prints in 1949.

It is fascinating to compare his early hand-drawn colour separations for these prints with the increasingly complex ones he has experimented on in connection with the diazo process he has used at the Curwen Studio since 1973. The richness and sensitivity of the forms that he can sculpt from the paper by the use of progressively deepening shades of a neutral colour against the white of the original sheet retained to suggest light falling across the figures, represents a way of working, in which Moore can certainly be seen as a pioneer, outside the hallowed but rather narrow traditions of stone lithography.

A change of attitude to drawing in the 1950s, when Moore all but abandoned it in favour of three-dimensional maquettes for sculpture, had its effect on his graphic art, which dwindled to a half-dozen lithographs spread spasmodically over a decade, and undertaken mainly for continental publishers. Stanley Jones of the Curwen Studio recalls going to see the artist around 1960 with Herbert Simon to try to persuade him to do some more prints, but Moore refused, saying that he was not drawing much and that the use of maquettes was more important to him just then.

However, in 1963, an intense interest and involvement in lithography re-awakened when, during a bad winter which made the production of sculpture difficult, he made an extensive series of intriguingly related prints, their generation springing most intelligently from the inherent repeatability of graphic process, on which he capitalised.

Drawing up a *Square Form* idea on transfer paper, which was taken off onto stone, he editioned it not only as a self-sufficiently powerful black image, but asked the studio to try various over-printed combinations in a range of muted colours, so that he could select backgrounds for other figures from these permutations. One of them became a pale grey architectural structure within which he deftly positioned seventeen reclining figures; another variant in grey-green, where a swirling movement suggested water, became a river background for two recliners. They themselves had come to life in a group of six figures based on his metal sculpture drawn directly on stone for an earlier trial proof, and they found themselves re-united with their four companions, but simplified into black silhouettes, in yet a third print.

Jones comments that this proliferation of ideas was a thing Moore particularly liked about the print process, which could offer preliminary proofs as basic structures to stimulate his imagination. Moore explains: 'To begin with a completely blank sheet of paper – the idea has to come from your head. But afterwards, and once the paper gets some marks on it, once you have destroyed the blankness and virginity of the paper … from there you can work on. It's like somebody beginning a story, or making up a novel. It then develops on its own. But you need something to start you off'. David Mitchinson, who looks after Henry Moore's archive, confirms that it is fatal for him to leave any rare sheet he is trying to preserve for posterity lying about on a studio working surface. If he does so, the chances are that he will next discover it providing the substructure for Moore's most recent idea.

Until the 'black drawings' leading to the *Stonehenge* portfolio, and his recent development of the diazo process, this period in 1963 represents Moore's most direct involvement and enjoyment of the lithographic medium. For although he produced a whole spate of colourful lithographs later in the mid-1960s, they came from drawings made specially for the project, sent already fully formed on transfer paper by the artist to Wolfensberger, the Zurich printers.

While Moore's development of lithography preceded his interest in intaglio, in the end his love of the latter has perhaps outstripped it, and he is on record as preferring the physical touch of the needle on copper, able to rival the pen in its exquisite fineness, to the movement of chalk across transfer paper or stone.

In 1951 Merlyn Evans, already a seasoned printmaker and later to produce magnificent large intaglio prints in sugar aquatint and a liberated form of mezzotint, gave Moore his second lesson in etching. Among the proofs he printed for Moore then were three slight but delightful images; a girl lying prone kick-

ing her legs beneath an aquatinted sky; seven standing leaf figures which were to appear in Moore's sculpture the following year; and two tiny seated figures. These were forgotten, then taken out and dusted eleven years later, and eventually published by Gerald Cramer of Geneva. Frélaut, master-printer of a renowned Parisian intaglio studio, did the editioning, and he followed this up by visiting Moore's home in 1966.

Two other etchings of the Merlyn Evans period were then resuscitated – the tiny *Reclining Figure*, and the transformed *Mother and Child* both included here. Going, as they did, through five and four states respectively they are the harbingers of Moore's deepening commitment to the medium.

By 1969, after more sessions with Frélaut and an increasing tendency to sculpt his etched forms out of freely cross-hatched shadow, Moore was poised for the *Elephant Skull* portfolio. This justly celebrated work, based on an actual skull given him by Julian Huxley, was chosen from more than forty plates worked in the years 1969 and 1970. Moore discovered in the skull's complexities, caverns and landscapes, which suggested analogies with his own sculpture, new forms for which the experience engendered. Above all, since they were drawn direct on the plate, the creative force lay in the etchings themselves – not in associations with Moore's other work.

The inspiration Moore takes for his sculpture from cultural models, ranging from the Aztec idol, Chacmool, to Masaccio and other artists of the Italian Renaissance, is well known. Less often remarked upon is the strength of his admiration for Rembrandt, and its implications for his etchings. In 1969, some time between March and May, he visited the exhibition of the late etchings of Rembrandt at the British Museum.

'I found it terrifically exciting' he remembers, 'how Rembrandt, out of one fundamental plate, could create entirely different moods and suggestions and mystery. It really was for me a terrific lesson in what a fully expressive medium etching can be'.

The exhibition demonstrated how, having given etching a subservient role imitating drawing at the beginning of his career, in the works of his maturity Rembrandt allowed the medium, if not to dictate, then at least to suggest the next move. Willing to undertake radical alterations, and wielding the drypoint not simply for small corrections, but to increase the tonal range of his chiaroscuro, he went from richness to richness.

To all these things Henry Moore has responded in his recent intaglio work, such as the *Architecture* plates. As well as trying Rembrandt's use of surface tone, he has followed his practice in varying the paper to increase particular effects. The very names of the proofing papers and supports used for the *Elephant Skull* plates read like poetry: vellum, Arches, vergé Hollande, Rives, vergé Montval, Guarro, Auvergne, Japon pelure … and now Moore is considering the hand colouring of the paper to receive small editions of a printed plate on top – a tip which Rembrandt, in his turn, probably learnt from Hercules Seghers.

But the essential feature of the Rembrandt experience lay in the interiors where, with nothing more than black ink on white paper, the artist makes light mysteriously reveal the forms. 'Mystery' is a key word in Henry Moore's vocabulary, and he equates it with blackness, the half hidden, and the ambiguous. The quite unsurpassable blackness of intaglio, the transformations possible for figures who replace each other in the course of repeated reworking of an image on the tolerant metal, thus make the process especially full of rich possibilities for him.

The swift pen exercises of 1970, many of which achieved particularly happy results interpreted into etching, were again partially inspired by Rembrandt and the almost abstract calligraphy of some of his pen drawings. But Rembrandt is far from the only graphic artist Moore has found inspiring. On a radio programme broadcast on his seventy-fifth birthday, in the summer of 1973, Moore mentioned the prodigious graphic output of Picasso, who, during seven months of 1968, already far older than Moore, had made 347 intaglio prints at the rate of about fifty a month. 'There is no need to think anybody eases up in any way whatever' Moore told the interviewer.

In the winter of the same year, he injured a foot, an accident which prevented him from standing, and therefore temporarily curtailed his work on sculpture. Far from being inactive, he used the enforced rest from work in three dimensions for a renewed period of graphic activity. Moore told Lord Clark in a postscript he wrote for the book on his drawing published in 1974, that the aim of his draughtsmanship, which he still found synonymous with printmaking, had always been to think three-dimensionally. What he found so attractive about it now, was that it could be done without physical effort. 'I'm thinking of my old!! age – that if for any reason I'm unable to go on doing sculpture, then I know that drawing could satisfy me for the rest of my days'.

Henry Moore has always been generous with his work. The *Spanish Prisoner*, although in fact never editioned, was intended to raise funds for those afflicted in the Spanish war. He has on frequent occasions given an edition of prints to good causes – for a Swiss children's village charity, the Italian Art and Archive fund, an Israeli Soldiers' cultural benefit, and the Art Gallery of Ontario, where they have built a special centre for his work. And he also made editions to help the Florentine owner of his Italian gallery, whose premises were swept away in the flood in 1967.

In adding this graphic archive to the sculpture he promised to the nation in 1967, and promising that the Print Department shall have a copy of every print made in the future, Henry Moore has ensured that the Tate Gallery will become a centre where all who respond to his work will find it uniquely possible to study it in all its dimensions.

Except where otherwise indicated, the quotations from Henry Moore throughout this catalogue are those made in a taped conversation with the writer on 25 March 1975.

Graphic techniques

Of the four main graphic techniques – relief, intaglio, lithography and screenprinting – Henry Moore most consistently uses intaglio and lithographic processes, although two early woodcuts are numbered amongst his archive and he has made a few designs specifically for enlarging and screenprinting as wall hangings on cloth. But during the late 1940s and early 1950s he did pioneer a process little used by other artists, based on collotype. Although this experimentation was short-lived, the idea of drawing his own colour separations on transparent film, which was central to it, has had constant echoes down the years, and has been recently resuscitated as a lithographic technique of infinite subtlety.

Intaglio, which is on record as Moore's favourite graphic medium, is a method in which the image is cut or incised into a surface, usually of metal. The warmed plate is covered with a stiff ink, which is forced into all the incisions, the surface is wiped clean, and then a dampened sheet of paper is placed on top of the inked plate and both, protected by resilient blankets, are run through a rolling press resembling a mangle. The intaglio image is thus a cast of dampened paper, moulded into the inked incision in the metal. The process can be readily recognised, as a tell-tale platemark is pressed into the paper, and above it the intaglio line stands proud. The plate can either be rendered as clean as a whistle with a chalky hand-wipe, or surface tone, in the form of a film of ink left on the plate, may be retained. Rembrandt, one of Moore's heroes, achieved rich effects of chiaroscuro in this way and surprising variations from print to print may occur in the same edition. Another device which can be used at the printing stage is *rétroussage*, in which a dragged cloth draws ink out of the incisions, giving a misty effect to the line. Both surface tone and rétroussage were used in some trial proofs of *Two Tall Figures, Man and Woman* (2b and c) but finally Moore broke away from the wet-in-wet blurring of the originating drawing, desiring instead to assist the idea of confrontation between two personages by retaining the fine spiky quality of parts of the etching in a hard, blanched, crisp printing of the image.

There are two main ways of making a linear mark on a metal plate. The most direct is to take either a diamond-sectioned tool called a burin, or a sharp-pointed tool called a drypoint and either plough a very deliberate furrow, or scratch a more wayward incision into the metal. The burin cut, difficult to control on curves, produces a clean crystalline mark which can swell or fine down as the engraver wills; the drypoint raises a burr of metal which holds more ink than the cut itself, and prints as a rich blurry line. Experts say a drypoint line is easiest to cut but trickiest to print, because the abrasion of wiping and pressure in the press break down the burr. Moore rarely engraves, but, like Rembrandt, he frequently enriches an etching with the furry bleed to the line that drypoint gives.

Etching is an indirect process in which the metal is covered with a ground which can be either hard or waxy, but either way resists acid. Through this, the artist can draw finely or cursively, as he might with a pencil. There is not the resistance offered by metal to an engraver's burin. The etching needle does not score the metal, but merely cleans a path through the ground so that the acid may do the work instead. A variant of this is *soft-ground*, for which the artist draws into a tacky form of protective coating with a stylus, through an intervening sheet of thin paper. The line produced has a softer, slightly granular effect which can be seen in the print *Architecture* (3b), an image which appropriately exhibited this quality in homage to Rothko, although drypoint has also been used to give depth and mystery. It is also possible to open up the etching ground for the path of the acid with other

tools – the roulette, a little toothed wheel, has skittered its way across the surface creating an effect beautifully in keeping with the mood of swift movement in *Turning Figure No.2* (1d).

Another of the controls that can affect the print is the length of time the plate remains in the acid. A line etched for a minute or so can have a most delicate wispiness – as was used to capture the papery thinness of bone in parts of the *Elephant Skull* portfolio (4). A shade longer, and it will become wiry; yet longer, and the acid will bite so deep into the metal that the image prints with an encrustation of almost clotted ink, as in the *Six Sculptural Motives* of the *Il Bisonte* portfolio (7a). Yet for the forms of the same objects in the most complex development of *Reclining Figures 1972* (7b) a pen or divided point clearing the etching ground created a quite different airy spring to the line.

Henry Moore has tended in past projects to work chiefly in etched line without the addition of tone (but for that attained by cross-hatching), although his first teacher of etching, Merlyn Evans, was a devotee of one of the most laborious and dedicated of intaglio tonal procedures – the *mezzotint*. However, when he first worked with Moore in 1951, Evans taught him a rather simpler way of acquiring tone on a plate – *aquatint*. If one were simply to open up a large area of copper plate to the acid – a procedure known as 'open bite' – a kind of crater, unable to hold ink except around its edges, would result. To make a large area hold a charge of ink, one must fuse an aquatint resin – a powdering of tiny particles invisible to the naked eye – to the plate with heat. This forms a resist, and the acid bites a pitting of tiny crevices in the interstices between the dust particles which give a 'tooth' to which the ink can hold. The most common procedure is to cover the entire plate with aquatint, 'stop-out' by painting a varnish over the areas on which one does not want the action of acid, and then totally immerse the plate. The negative marks of the 'stop-out' brush can be detected in the aquatint of the trio of *Reclining Figures* etched on one plate (5). However, the artist may also paint the acid selectively on to the aquatint ground often using a feather, which will not rot. A light brushload left for a short time gives a dove-grey washy tone as can be seen in the same *Reclining Figures*. Left longer, as in the *Two Seated Figures* (8b), the brushed acid will bite the soft smudgy tones a good deal darker, and the effect is less mechanical than the more even tones to be achieved by total immersion. Moore maintains he has not done enough aquatint. 'You can get the most beautiful velvety

blacks, more beautiful even than a water-colour', he says, 'with a depth on the paper of distance and of mystery'. On this particular print, the artist has also used burnisher and scraper to smooth away the pitting and in effect 'rub out' the tone, thus economically suggesting light entering the room.

Recent prints in Moore's oeuvre reveal an increasing willingness to experiment with intaglio technique, particularly in the mixed methods employed in three plates for the abandoned *Architecture* book. His delightful combination of lithographic and intaglio overprinting, as in the *Il Bisonte* print (7a), is an occurrence all too rare with British artists, who tend to lock techniques in watertight compartments.

Collotype, on which the *collograph* is based, was, in 1949, the one *commercial* process able to render tone without the intervention of a mechanical screen. In most commercial printing processes, tonal nuances within a single colour can only be suggested by submitting the image to a ruled screen which breaks it up into a system of dots, known as half-tone. Pale areas are rendered by a light distribution of tiny dots, dark areas by more closely clustered large ones. Thus a black plate, which in reality prints all or nothing, can give the optical illusion that there are nuances of grey. The collotype plate is a film of gelatine made sensitive to light, deposited, at that time, on glass. When a collotype plate is exposed to a colour-separated transparency and then developed, the gelatine remains hard and dry in the dark areas, but swells so that it will absorb moisture in the pale ones. The most important factor is that when treated, the surface crazes into an irregular reticulation which creates tone, undetectable precisely because of its irregularity. It is a method unsurpassed for the facsimile reproduction of water-colour. Unfortunately, because of the skilled craftsmen it demands, the shortness of the printing run, and a fickle tendency to react to the weather, it has all but died out, and Ganymed, who claim their invitation to Moore to experiment was the first autographic use of it, no longer use the process.

The term collograph, which they coined to differentiate it from reproductive use, should not be confused with coll*a*graph, which is an American twentieth-century collage print development. The autographic use of collotype entailed the artist in separating out his own colours, rather than having it done photographically from an original, and Moore found the possibility for putting the transparent separations one above the other gave

him considerable freedom, in a way much less arduous than the traditional lithographic method. He also liked the fact that collotype had no grain, which at that period was always a characteristic of lithography.

As all Moore's transparencies were destroyed in observation of the cancellation procedure that ensures a limited edition cannot be reprinted, the transparencies for a trial run of a quarter of the collograph *Standing Figures* of 1949 (10a-c) are the only surviving examples of his preparatory work for this medium. The positive wash drawn for the yellow, and the print made from it, show the extraordinary sensitivity of the process, and it is also a revelation to compare this yellow trial printing with the redrawn yellow on the completed print, in which the densities of the wash are redistributed in such a way that the figures now emerge three-dimensionally from their background in an unclouded clarity of blue. Moore relates that the moment when he saw the sum of his separated washes and drawings amalgamated into the first proof had something of the excitement of the potter viewing a glaze emerging from the kiln, or a sculptor seeing his plaster original cast in bronze. 'Now when I make a plaster for metal, I know what will happen nearly exactly' says Moore. 'Then it used to be an excitement but also a trepidation. Well, the collograph was the same'.

Lithography of the 1940s was also adapting the transparency technique to its repertoire, although collographs were still more sensitive, as grain was an inescapable part of the lithographic plate, unable absolutely to register the delicacy of Moore's washes. However, a notable series was commissioned by School Prints, and printed by W. S. Cowell at Ipswich. Stanley Jones, the master lithographer at Curwen Studio who now prints a great deal of Moore's lithographic work, with a process on aluminium plate which he feels can match the sensitivity of the collograph, admits that at the time Moore did these early prints, most printers, including Curwen, were in a pre-war technical situation and would not have experimented with the processes the Cowell firm was then using.

The older form of lithography, of course, is a method of drawing upon a grainy limestone with a greasy medium, obtainable either in crayon or liquid form. Based on the antipathy of grease and water, this drawing then attracts the oil-based ink while the chemically fixed and dampened stone rejects it. The image is planographic – that is, it is neither raised like relief, nor incised like intaglio, but is locked into the granular surface of the stone. The drawing is fixed in an operation confusingly known as 'the etch' in which gum and nitric acid prevent the grease spreading.

An important and sometimes an inhibiting factor about traditional lithography is that the artist draws blindly, for what is decisive in the print, and determines the weight of the mark made, is the amount of grease deposited on the stone. The liquid tusche or crayon is blackened so the artist can see roughly what he has drawn, but this colourant does not necessarily correlate with the grease content and is quite immaterial to the final result, since it is washed out leaving only the now invisible grease drawing. Only when the stone is rolled up with ink does it reveal the image again. The grain makes possible the nuance within a single colour, for pressure of the artist's hand deposits grease lightly or heavily into the grain. But another inhibiting factor is that if you draw direct on the stone (as Moore did for trial proof 14a in 1963) you must reverse your image in the drawing so that it will print the right way round. This is true of etching, too.

The traditional way of circumventing this situation is to draw on transfer paper which the printer can then print down on stone (or the grained metal plates which are gradually replacing stone) by running both through the press face to face. He may even transfer the same image more than once, as was done for *Square Forms* (14d), where the drawing of the trial proof (14c) has been put to stone twice, once inverted. Moore used this drawing in endless permutations and overprintings for the background of several prints in 14, notably doctoring it on the stone for one (14f) by treating it with nitric acid so that highlights in it would create a more suitable backcloth for the seventeen superimposed forms.

Stanley Jones maintains that transference nearly always means some loss of original quality – perhaps only 90 per cent of any drawing being retained – and the work invariably needs retouching. The quality of the transfer paper also affects the result. Very coarse paper has been deliberately used in 15a to assist the craggy quality of the dominating forms originally envisaged.

Since the 1960s there has been a development in lithographic printing, important in its implications for Moore's work, called the *diazo* process. This employs a sensitised coating on an aluminium plate no longer inevitably granular. By making his preparatory work in the form of a photopositive in dark ink or wash on transparent film, Moore continues to provide drawings

which are not completed artworks in themselves, but are created specifically for transfer to the surface of the diazo plate by ultra-violet light. This is not a method employing photographic lenses or any kind of mechanical screen, but one of direct transfer, in which the infinity of tiny dots of ink in the artist's positive are translated into continuous tone on the plate. It's a method regarded by Stanley Jones as a more sensitive and faithful means of transferring an artist's idea than the traditionally used paper. Its added advantage is that while stones are unwieldy, and metal plates may oxidise, the artist can spontaneously, wherever he happens to be, take out a sheet of transparent film whenever an idea occurs to him, confident that anything he draws will be predictably captured in the printed image with absolute fidelity.

There is, however, a degree of manipulative freedom in the method, in that length of exposure to the light affects the result. Light softens the diazo coating so it can be washed from the aluminium, leaving only the ink-attracting printing surface. The longer a transparency is exposed (one might liken this control to the pressure exerted on a transfer paper going through the press) the more diazo coating will wash away. Thus, long exposure means only the very darkest areas of Moore's positive will be captured, short exposure means the lightest working can be retained, and of course an infinity of gradations is also possible.

Thus even in a basically monochrome print, there may be a range of values within one shade and this has led to the almost sculptural modelling of the *Four Reclining Figures* 1974 (13c).

Nor is this a particularly new idea: historically lithography has often been unable to give credence in one printing to the endless values possible between black and white. Eugene Carrière's prints are a case in point, where only transfer to several stones and repeated overprinting could achieve the density he wanted. And sometimes fine commercial printing will echo the artist, as it has done in this catalogue, where the black-and-white illustrations, theoretically possible from a single black printing on white paper, have achieved greater subtlety by being printed in two tones.

Thus Moore, from his earliest experiments in collograph to the latest ramifications of diazo lithography, can be seen as a pioneer of the use of a transparency specially drawn for the print process. Much of his ingenuity has consisted in inventing different ways of creating these positives – combining different inks which 'curdle' or dry out with fascinating concentrations of tone around the edges, adding touches of pencil or crayon to the wet wash, scratching into a dry drawing, and continually reverting to the wax resist used to repel wash and suggest highlight so famous from his war-time *Shelter Drawings*.

below: pen drawing

opposite page
top left: black etching with hand colouring
bottom left: etched colour plate added
top right: *Turning Figure 1*
bottom right: *Turning Figure 2*

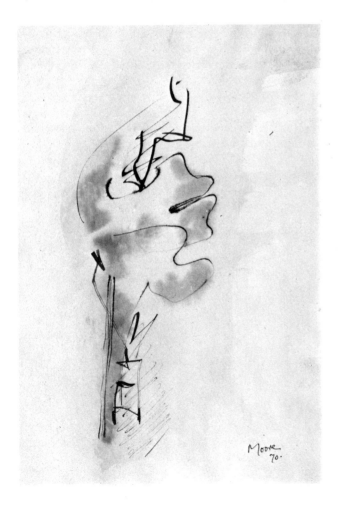

1 TURNING FIGURES 1971

The drawings of 1970 represent a singular development in Moore's work in that they celebrate swift movement.

Moore says the stimulus for them came from the combined influence of the marvellous abstract calligraphy of much of Rembrandt's pen drawing, and the Harari collection of Japanese art, also calligraphic in nature, which he visited at the Victoria and Albert Museum.

'For about a year, in responding to this', says Moore, 'I got conscious enjoyment from doing pen exercises. In one's mind this [indicating *Turning Figure No.1*] was a form. This was a big arm coming over the cross, this a head, this the middle of the figure.... But the head was turned, so then I thought of a figure on a base, turning. Part of it is a form I've used in sculpture'.

The *Turning Figures* come from two similar exercises done at about the same time, which were developed side by side as etchings on one plate. Working out the next step for the etching by drawing on the last proof, as is his habit, Moore placed each figure in a room setting made gay with pen hatchings of orange and yellow striping respectively, although almost immediately a black crayon toned down the yellow pen work.

Nevertheless, a colour plate was added to the black one and was proofed in similarly bright colours – red for the room on the left, yellow for that on the right. But once again, Moore thought twice about this gaiety, and the two *Turning Figures* were eventually placed in restrained settings, one of dun brown, and one of soft grey.

'The yellow, and so on, strike you first', explains Moore. 'In the final print I wanted the black figure to be predominant, so I reduced the colour'.

'I like colour. I like it. But colour for me is a bit of a holiday. It's not what it is to a painter ... There can be a kind of ... I don't know what! You see, colour can be used to prettify almost, or to make attractive – to give popular appeal. Because the average person responds immediately to colour. But I like the saying of Degas – "Black and white are enough to make a masterpiece".'

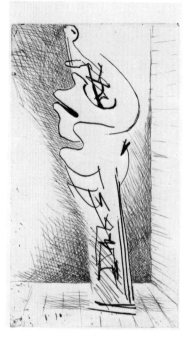

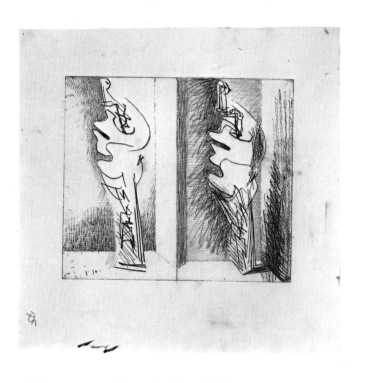

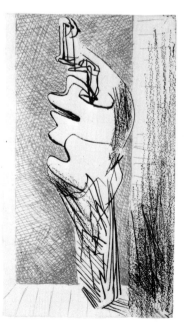

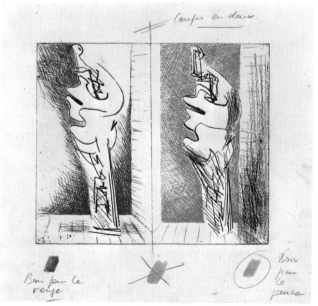

couper en deux

Bon pour le rouge

Bon pour le gauche

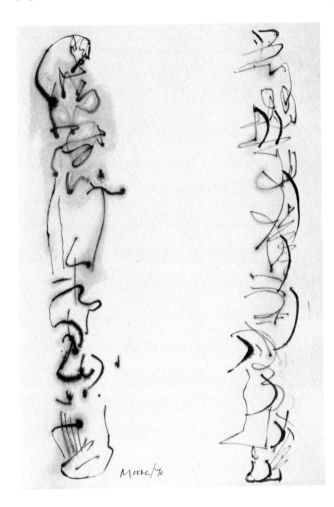

2 TWO TALL FIGURES, MAN AND WOMAN
1970 and 1971

Two Tall Figures, Man and Woman emanates from the same set of pen exercises that Moore made in 1970 which generated other prints in this book. The original idea was a pen drawing on damp paper, in which the ink had flooded and burgeoned out into textured pools.

The drawn figures were repeated in the etching. 'What I wanted', said the artist, 'was a kind of – not wild – but a kind of vitality, with thin spiky forms like this one ... prickles almost. This [indicating the right-hand figure] is meant to be a friendly arm, and two people stand confronting each other. But here, the forms have become ... but this was not consciously done ... closed at the front in a kind of opposition. This pointed, jagged line [indicating the left figure] shows what etching can do. I wanted to get this contrast between the very thin line that etching can make, and this thickness; that wasn't so easy to do'.

Various attempts were made to vary the effects of the figures during printing, some of them referring back to the flooded ink of the drawing. These, by leaving a film of surface tone on the plate, or by dragging the ink out of the incisions in a technique known as rétroussage, aimed to capture certain aspects of the original idea. Two early proofs of the figures by themselves, one a crisp clean print on vergé Montval in which the ground has been indicated by pen, the other a softer printing on a more absorbent paper using ink manipulating devices, are an object lesson in the different effects to be achieved from the same plate.

A background plate was made in a rhythmic arrangement of quivering lines, suggesting tremolo sound waves. It was proofed both in brown and grey, with alternative trials for both crisp and blurry qualities. In the final edition, the softer qualities of the drawing have been left behind. Instead, the contrasted thick and thin calligraphy provided purely by the etching process itself has been sharply printed. Thus one prickly character, whose concave forms are theoretically open and receptive, confronts the other extending a friendly limb, behind which his façade remains confusingly convex and closed; a paradigm inviting imaginative conjecture on the mysterious ambiguities in all relationships.

above: pen drawing

opposite page
top left: 1st state etching
bottom left: 2nd state alternative printing
right: final state

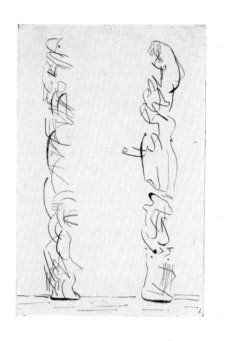

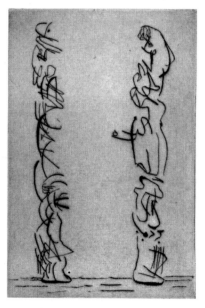

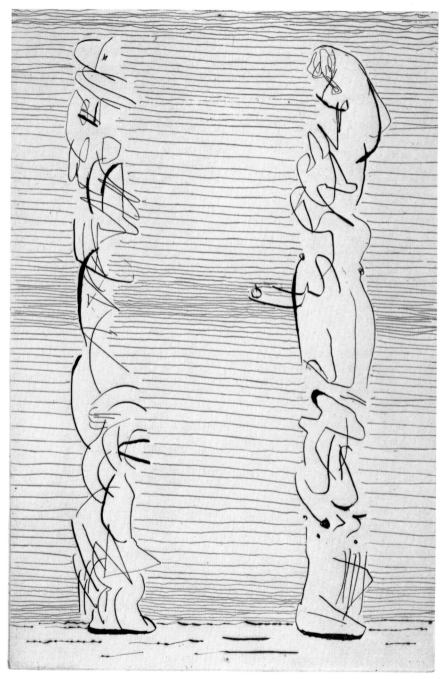

9 TWO SEATED FIGURES 1970 and 1971

A swift pen drawing touched while wet with orange water-colour, which has blossomed into the paper, was the stimulus for part of this etching. Interestingly, the figure was not reversed on the plate, but sits as she sat in the drawing, simply acquiring a companion by the first state. Although the couple at this stage are not yet within a room setting, cast shadows already suggest a light source, and when this subsequently appears, one is re-minded of Rembrandt's fascination with light falling onto figures in an indoor setting, by way of a window.

Characteristically, Moore took the first state and drew the way he wanted the print to proceed on top of it, using black and rust inks to detail the figures and scrubbed colour to suggest a dark background. The head of the left-hand figure was later redefined, and a child grew magically from curves about the mother's body which had suggested it.

A beautifully washy aquatint added to the black plate provides a matt velvety background against which the figures stand out, lightly burnished to indicate the window, suggest the merest wisp of curtain and illuminate the corner of the space. The contoured red bricking which amplifies the forms and creates the child, is printed from a second plate in a rich rust-coloured ink.

Moore said in 1974 that putting figures into settings – pictorial drawing, in fact – was firmly associated in his mind with making holes in sculpture trying to make the back of the sculpture connect through to the front. He refuted the idea he was given as a student – that a sculptor's drawings were somehow different from those of a painter. 'I was interested pictorially in making an object placed in space – either in a room, as one did with a whole lot of those sculptures in rooms, or in a setting that related one or two objects to each other, drawing space between them'.

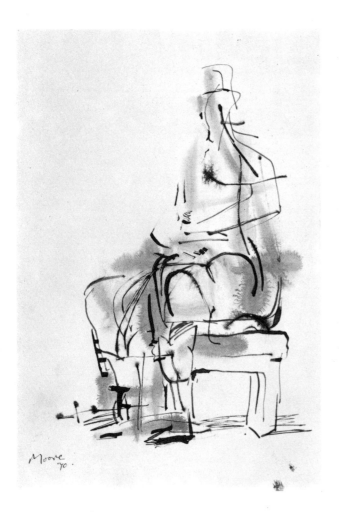

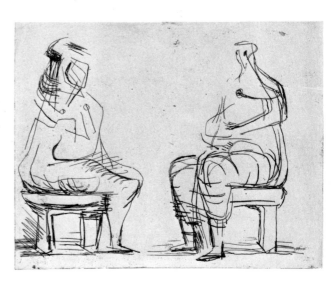

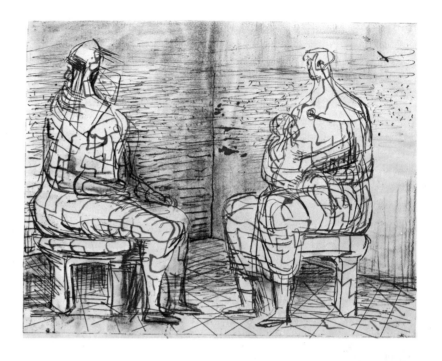

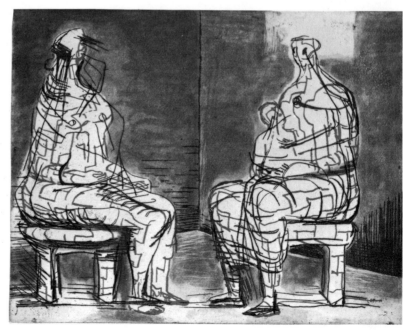

opposite page
left: pen drawing
right: 1st state etching

this page
top: 1st state, hand-coloured
bottom: final state

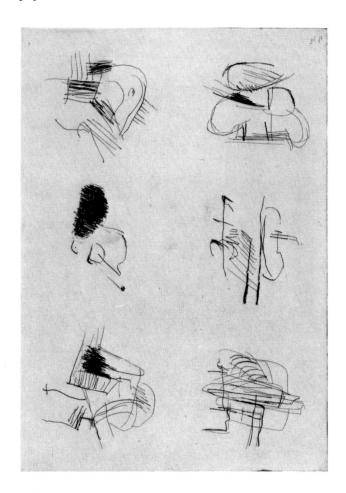

above: 1st state etching

opposite page
top left: 1st state retouched (detail)
centre left: 3rd state (detail)
top right: 4th state retouched (detail)
centre right: 5th state retouched (detail)
bottom: final state (plate cut)

5 RECLINING FIGURES 1970 and 1972

Moore says that just as Leonardo mentions finding landscapes in a wall spotted with stains, so he could find, in any mark, any smudge, a reclining figure. In this print, he has done precisely that. Six abstract exercises, springing from a delight in manipulating a pen, are developed in pairs into *Reclining Figures I*, *II* and *III*.

Following the fortunes of just the bottom of the three figures, *Reclining Figure III*, we find her taking shape as Moore, working in a way which recalls his transformation drawings, takes a copy of the first state of the etching, and develops the wispy abstract strokes made by the etching needle by drawing on top with a fine pen-line. A bridging lap joins the two separate sections together and a suggestion of a column at the left develops into a neck surmounted by a tiny head in profile, while the legs which the original calligraphy has fortuitously draped, are defined by judiciously throwing the chasm between them into shadow. Then a room appears, shaded by scribbled hatching and crosses, while the perspectival lines of the floor place this resting but wide-awake creature, firmly within a space.

This development in pen and wash is realised by the third etched state. But the tone applied to the floor-boards by brushing acid directly onto an aquatint ground, is, by the fourth state, judged still too pale. The figure is restated on another proof with black paint and heavy black crayoning, vigorously applied. At the same time, to avoid decapitating the lowest figure, the ceiling of her portion of the plate, later severed, has to be raised. By the fifth state, a heavier aquatint, achieved by painting a resist over parts of the ground and immersing the plate in acid, raises the height of her background wall, and sets her in greater depth and shadow. Momentarily, by the touch of a brush on this proof, her breasts are uplifted, and she stares round at us full face.... But, finally these adjustments are not carried out, and the tiny head remains in profile, much as it was in the beginning.

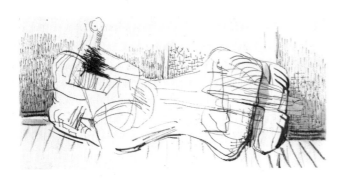
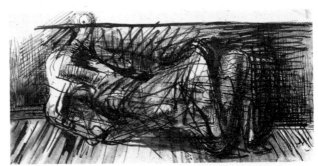
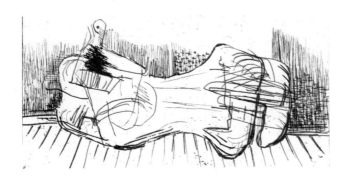
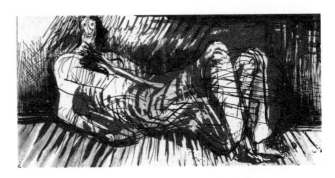
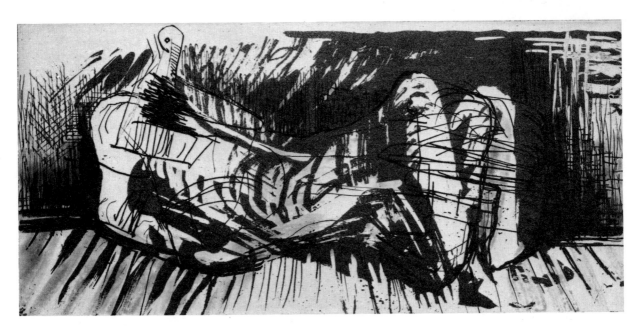

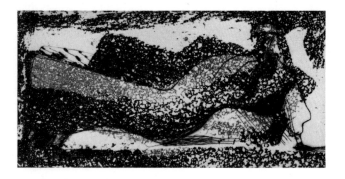

above: 1st state etching

opposite page
top: 1st state retouched
bottom: final state

6 RECLINING FIGURE 1951, 1962 and 1966

This tiny etching is one of a number begun when Merlyn Evans was staying with Moore and teaching him intaglio technique in 1951. It was taken up momentarily for burnishing in 1962, reworked with etching and drypoint in 1966, then editioned by Frélaut in Paris later that year.

The reclining figure is not only the most perennial of Moore's themes in sculpture – graphics also declare his unfading interest. In this case, the figure is shrouded in an almost woolly robe created by heavy drifts of aquatint resin. The burnisher has polished a highlight along the leg, while various ingenious textural marks suggest either a twin, or a shadow. The redrawing of the head to occupy a white space near the right edge of the sheet while the first can still be vestigially perceived to the left, reinforces the idea that she has a companion. Or perhaps it suggests Futurist movement – she may well have stretched, yawned, repositioned her arm and emitted a light sigh.

It is unusual for Moore at this time to progress through five states in order to realise an idea, for most frequently his early intaglio essays take him directly from conception to completed work, with perhaps only a corrective touch of drypoint. Practical considerations, if nothing else, would have prompted this, for he had no proofing press at his home.

The arrival of the master-printer Frélaut in 1966 to take over the printer's role where Merlyn Evans left off marks a new attitude to intaglio, a process which may positively thrive on reworking. Lack of printing facilities at Much Hadham meant Frélaut had to travel over thirty miles to etch and proof plates at the Royal College of Art in London and thirty more to bring them back for Moore's approval. All forty plates for the *Elephant Skull* of 1969–70 were produced in this fashion. So Frélaut must have been especially delighted when in 1971 Alistair Grant made Moore the gift of a proofing press.

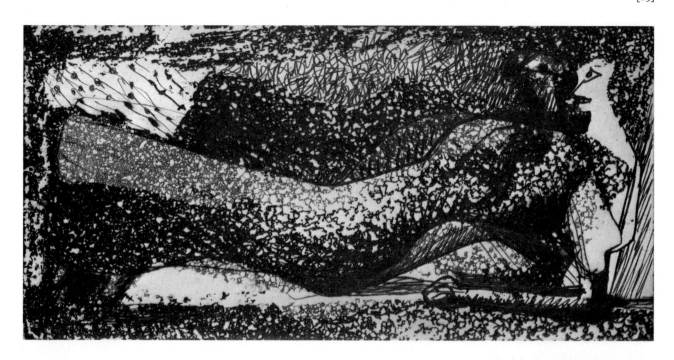

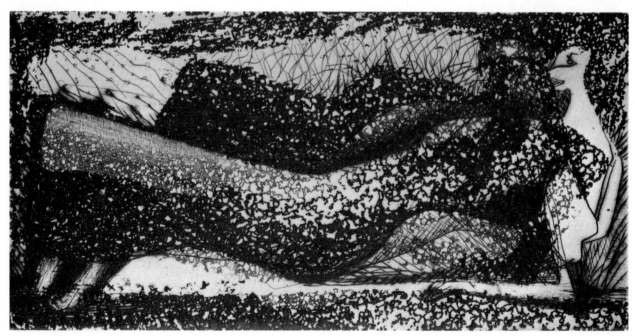

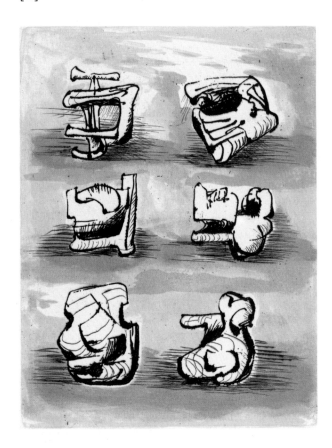

The genesis of these three related prints, which stem basically from the same 1970 drawing, is extraordinarily complex. So much so, that it was a detective operation, even for the artist himself, to unravel the way the idea unfolded.

The complications arise from the fact that the drawing now signed 'Moore 70' in the left-hand corner of one of its long sides, is a wash and crayon development of six earlier and simpler pen studies of sculptural objects. By turning the drawing through 90 degrees and mentally subtracting the crayon and wash, its original form can be divined, and a partially obscured signature, confirming its previous orientation, can be seen in the right-hand corner of its shorter base.

The first state of the etching is virtually a mirror image interpretation of this first form of the drawing, in which the most easily identifiable object (perhaps a tap in communion with a stool?) travels from the left-hand top corner of the drawing to the right-hand top corner of the etching, reversing in the process.

In 1970, the first etching, based on the simpler version of the drawing, was temporarily abandoned, but its first state clearly inspired a quite separate print, in which the same six sculptural objects reversed back on to another plate for the *Il Bisonte* portfolio.

This time, instead of removing the etching ground with a two-pronged tool giving a flexible double line, the new variation contrasted a hairlike line in the shadows with a richly encrusted treatment of the objects. In these a deeper bite in the acid threw them into relief in black against paper previously lithographically coloured – an unusual combination of techniques.

Meantime, Moore had turned his drawing through 90 degrees and visualised the objects joined together, not sideways as reclining figures, as eventually transpired in the two prints (7e and f), but vertically as seated figures. At first he gave each of the six stone objects a head in its new orientation, but later suppressed the heads of the lower figures at either end, and created forms in which the top half of the figure becomes fused with its lower stool or base.

A drawing of 1971 (No.77 in Lord Clark's book on Moore's drawings) shows a fully modelled chalk and wash treatment deploying the same six sculptural objects, in a way more in keeping

above: Six Sculpture Motives

opposite page
left: 1st state etching *Reclining Figures*
right: drawing: *Ideas for Sculpture*

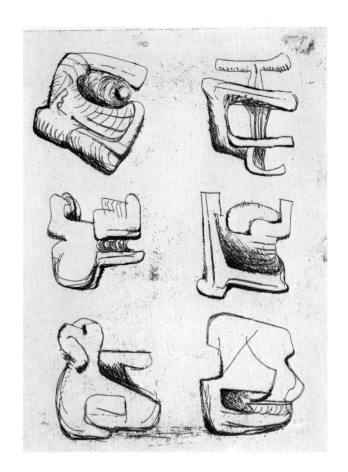

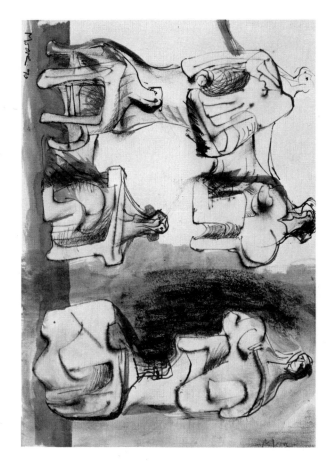

with their final disposition in the two etchings, with four joined in pairs to create *Two Reclining Figures* and *Reclining Figure IV* developed at right angles.

Richly embellishing a proof of the first state with crayon and intricate penwork, Henry Moore completely redesigned the plate, and on 17 November 1972, perhaps because he had worked out the similar progression of sequence 5 the previous day, he went swiftly through to the final version with two, rather than five, intervening states.

The tap form is now at the base of the *Two Reclining Figures*, lost in shadow. *Reclining Figure IV* on a different axis, may owe her more comfortable pose, lying down with an arm raised to her head rather than sitting solidified to her seat, to an original ground-line accidentally reinforced by foul bite.

This ability to transform one thing into another, to allow a latitude for the imagination in the way metamorphosed forms are read, or in which a single form may be variously interpreted, is central to Henry Moore's sculpture, but takes on a new aspect in this intaglio work. At the same time those prints in which he constructs a figure by joining two sections together make an interesting reversal of his customary sculptural procedure of taking one apart.

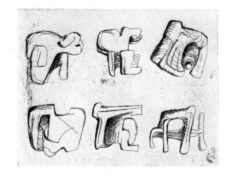

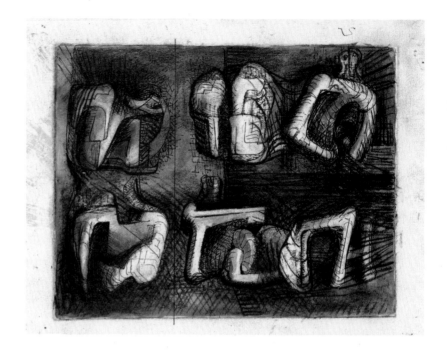

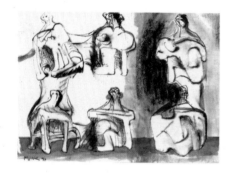

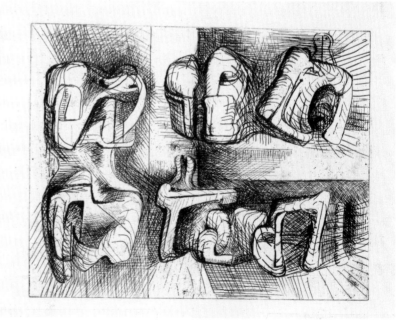

opposite page
top left: 1st state *Reclining Figures*
bottom left: drawing: *Ideas for Sculpture*
top right: 1st state plus drawing *Reclining Figures*
bottom right: 2nd state plus pen

right
top: *Two Reclining Figures*
bottom: *Reclining Figure IV*

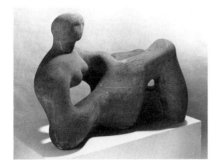

Recumbent Figure, 1938

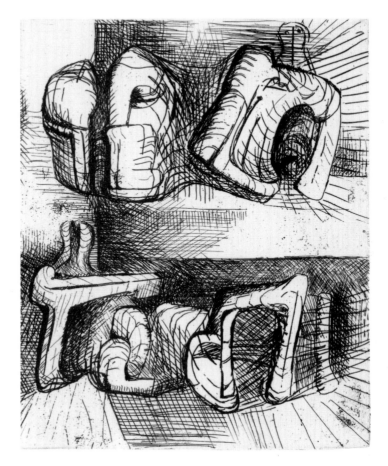

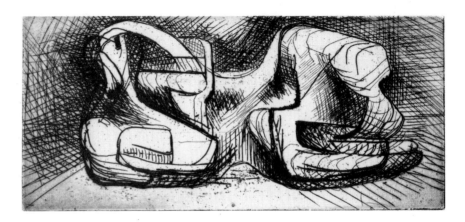

8 SEATED MOTHER AND CHILD 1951 and 1966

This print was also begun in 1951 under the instruction of Merlyn Evans. In its first state, with a hint of aquatint and a smir of surface tone, the two bone-like figures which Moore says were 'in some sort of conversation, controversy or relationship' were set aside for fifteen years, until Frélaut, master intaglio printer of Frélaut and Lacourière in Paris, started spending fortnightly periods at Much Hadham.

Looking at the print again in 1966, Moore decided the forms were purely arbitrary and 'needed a meaning putting into them'. So he reworked it for the suite *Meditations on the Effigy* published on the occasion of his seventieth birthday. The resultant figures remind one of the anthropomorphised pebbles and bones of his transformation drawings of the 1930s.

By drawing in pen all over the first state of the print, the right-hand figure was reconstructed and brought from a standing to a sitting position with a child perched on her lap. Instead of a rounded base of bone, she is now stabilised by an extraordinarily shapely pair of legs. The attendant left-hand figure, still rather bone-like, has been submerged in a flurry of drypoint strokes, and one or two other figures are suggested distantly beneath the rain of lines.

Robert Melville, who wrote an introduction for the suite, imagined that the left-hand figure was 'father as bogey man', but Moore (not without echoes from Renaissance painting), felt it may have been a figure helping to bath the child; certainly he wanted it to be less important than the mother. In keeping with his practice of metamorphising one thing into another, he has retained a certain mystery, and the protagonists are capable of a variety of imaginative interpretations.

The concordance between the drawing developed on the first state of the etching in pen, and the final result is technically astonishing. This had to be reversed in order to interpret pen line on metal, and although it has not been a slavish copying, the feat is achieved with uncanny sureness.

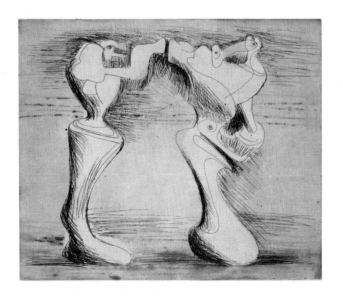

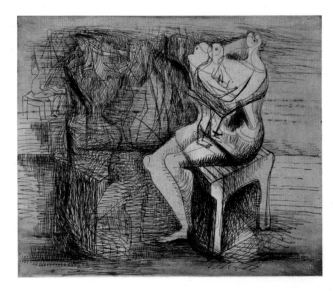

opposite page
left: 1st state etching
right: 1st state plus pen

below: final state

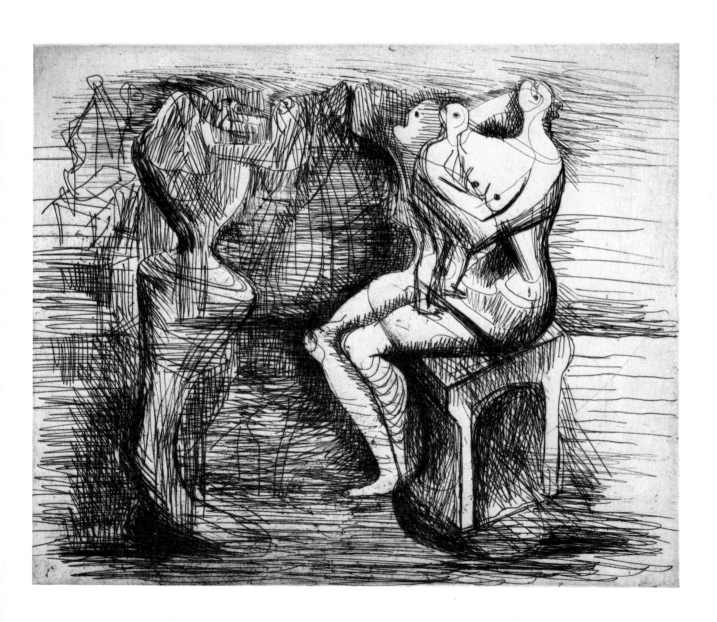

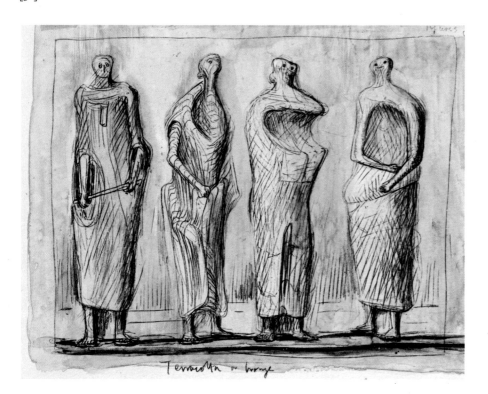

10, 11, and 17 STANDING FIGURES, WOMAN HOLDING CAT and FIGURES IN SETTINGS 1949

These three collographs, only two of which are reproduced, were made in 1949 from autographically drawn transparencies.

A trial photopositive for *Standing Figures* is a rare survival from the artist's archive together with a proof of *Woman Holding Cat* marked up for the printer. An alternative colourway for *Figures in Settings* has been presented to the Tate by Dr Bernhard Baer of Ganymed. He remembers that sometimes, after seeing the first proof, Moore would rework the transparency. Or else he would mark up the proof with all sorts of instructions to the printer: to modify colour, to close registration gaps, and so on. The marked proof of *Woman Holding Cat* which has survived is an interesting example of this action, requesting the printer to lighten or darken certain patches, and indicating with blobs of colour the particularly vivid red that he was after. Moore has told of the excitement of seeing the first colour proof, previously only visualised as the sum of his monochrome separations, and he likened the experience to that of the potter taking his glaze from the kiln, or the sculptor his bronze from the mould: one could control the result to a certain extent, but there was still trepidation and surprise.

The man who suggested to Moore that he should print at Ganymed was E.C. (Peter) Gregory who in 1959 bequeathed to the Tate the Armenian marble *Half Figure* of 1932 which is included in the exhibition. Publishing experimental prints at the time, even by an artist with a name as illustrious as Moore's, was a considerable act of faith. Although a healthy market had existed, especially for etching, at the beginning of the twentieth century, wars and economic crises severely crippled development, and that later flowering, which has since been dubbed the British Print Renaissance, did not really get under way until the late 1950s and early 1960s. So these collographs represent an exceptionally early stirring of the post-war revival of interest in artists' prints.

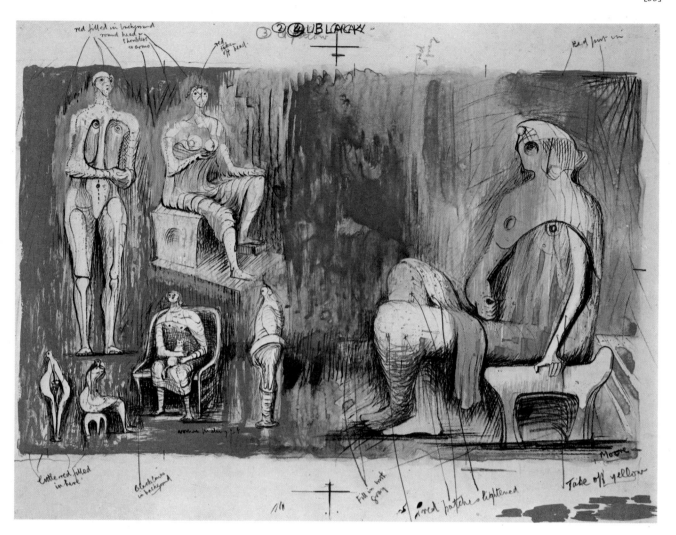

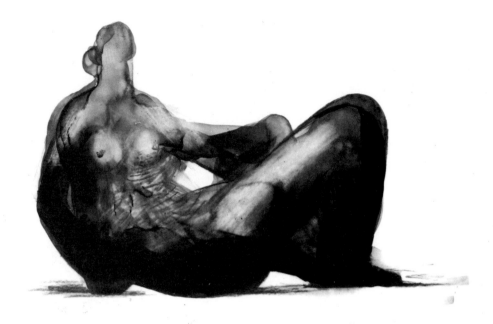

13 FOUR RECLINING FIGURES 1974

These two related lithographs were made with the diazo process (more fully described on p.14) which Stanley Jones, Moore's lithographer, regards as a more sensitive and reliable method of lithographic transfer than the traditional paper. Moore first used this development in 1973.

The majestic large-limbed reclining figure, drawn with the twisting use of a brush in lithographic ink on transparent sheeting and then touched with pencil, is one of four related figures used in two variations. Having experimented, Moore combined various inks and water-colours, working them wet-in-wet to get fascinating effects (not unlike lavis on stone, and seen to perfection in the beige background) in which a suspension of powder in the medium precipitates out. He also liked the sensitive edging, caused by the medium drying out finally at its circumference, which he feels would be a difficult, if not an impossible effect to achieve by normal lithographic method. 'Every medium is there to be exploited' he says. 'Every medium can do things other mediums cannot, and therefore you try to use that'.

One of the advantages of the method is that the placement of figures against the ground, so vital to the balance of this print, can be less laboriously achieved than by drawing all four simultaneously: one simply cuts the figures out and fixes them to their best advantage in relation to the background; patrician heads positioned in the swirling eddies of a cloud-banked sky. The highlight on the figure – the concept of light falling on a form so central to Moore's work in all media – is achieved by leaving the white of the paper, while the lavis of the sky has an under-printing of paler tone which acts as its springboard. The figures themselves are sculpted from three closely linked neutral tones.

The version Moore adapted for the Art Gallery of Ontario, where a centre to house a gift of his sculpture was recently opened, appropriately houses the four figures each within its own cave or alcove. The cave, too, is a recurring theme in Moore's work, and he has said that the piercing of his sculpture with holes to increase its three-dimensional quality, is related in his mind with pictorial suggestions of depth.

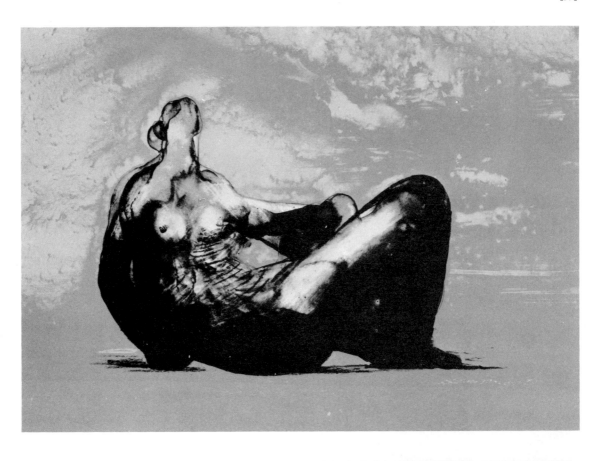

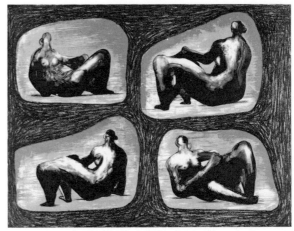

opposite page: transparency (detail)

this page
top: *Four Reclining Figures* (detail)
bottom: *Four Reclining Figures; Caves*

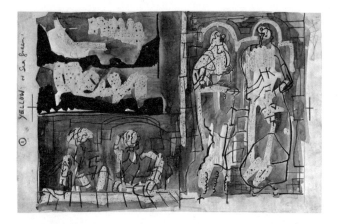

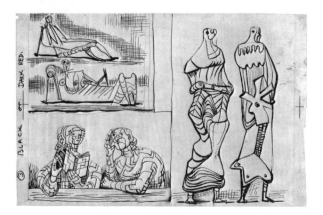

12 and 18 TWO STANDING FIGURES WITH STUDIES ON THE
LEFT c.1950
SCULPTURAL OBJECTS 1949

This lithograph, made with the same kind of autographic transparency as the collotypes and the diazo lithograph, is in its way a very forward-looking example of the early lithographic use of this process. But as Moore has pointed out, it shows the characteristic grain of the medium which made the nuances of continuous tone in wash a tricky thing to produce at this time. Only two of the three transparencies used in actually making plates seem to have survived, and the print was never editioned. The colours have been tried out in various combinations with the line either in red or black, the background in sea-green or yellow, and its overprinted modifications either in red or brown.

There are four extant proofs of which one is a simple green/red/brown printing, while the others have colourful crayon and water-colour background additions which in all cases throw the rather courtly armoured standing figures on the right side into higher relief.

Wax has been used on the background photopositive to create a resist to the wash placed over it, and this transparency drawing, which combines pen, pencil and wash together, creates a precedent for the mixed media transparencies Moore now fashions for his diazo lithographs at Curwen.

This new method of drawing on plastic plates was taken up in a big way by Brenda Rawnsley of School Prints who conceived the idea of making some original lithographs, rather than colour reproductions, for school-children. She made a very enterprising sortie to France to enlist artists of the calibre of Braque and Picasso, who both acceded to her request, the latter drawing her, complete with melon and sunhat, as she had appeared on the beach to which she finally tracked him down. At the same time, she persuaded notable British artists to follow suit. Among them was Henry Moore, who drew six colour separations for an exceptionally large and splendid group of sculptural objects printed in an edition of 3,000. Without making any patronising concessions, it is masterly in its gay appropriateness as an imaginative stimulant for the young. The transparencies for all the School Prints lithographs of 1949 in this series were given to the Tate Gallery by School Prints in 1971.

opposite page: transparencies

right: two variant three-colour
proofs with hand colouring

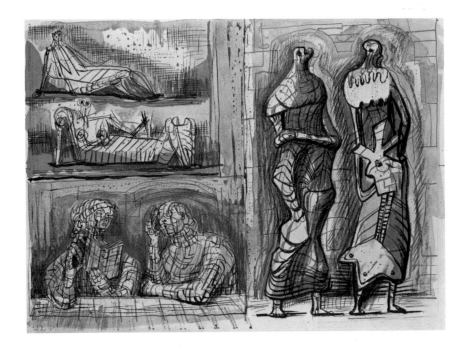

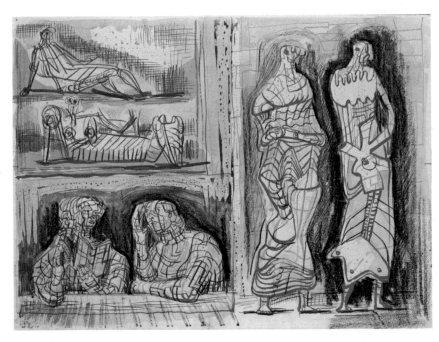

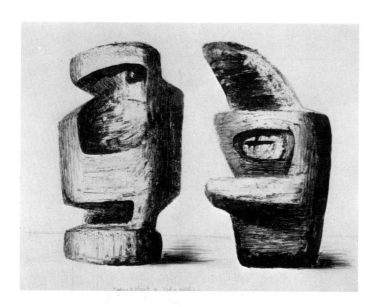

left
top: background trial
bottom: final state lithograph

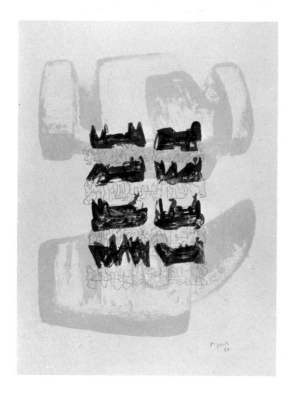

15 EIGHT RECLINING FIGURES ON ROCK BACKGROUND
1963

This lithograph, from an extensive series of prints which the artist made at the Curwen Studio during the bad winter of 1963, has its precursors in the square and menhir-like stone forms of the 1930s, which Moore resuscitated in several drawings in 1959. The left-hand figure in the black and white trial proof comes from just such an *Idea for Sculpture* drawing (No.188 in David Mitchinson's book *The Unpublished Drawings*) and this form was joined by a similar figure. The lithographic drawing was on very coarse paper which partially broke down on transfer lending the image a crumbly texture. It is an interesting example of the way in which the chosen medium can considerably add to the concept – in this case of uncompromising weight and power.

The trial proof was refined by pastel additions as if the image was intended to stand as an idea on its own. It was never thus editioned. Turned on end, muted to a subtle shade of pale stony green, and ignoring rectangular format, it became the rock background for eight reclining figures linked together by intricate calligraphy. Printed in brown and viridian, these figures were proofed five times before a balance between all the forms could be achieved.

14 SQUARE FORMS and
RECLINING FIGURES 1963

right
top: lithographic trial proof
bottom: *Six Reclining Figures with Buff*
Background

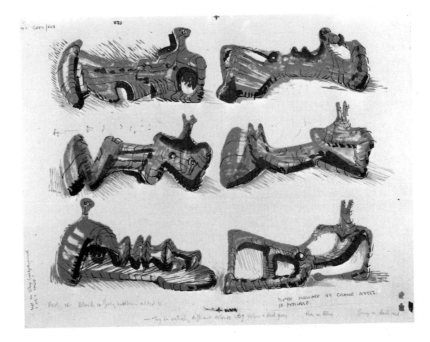

Reclining Figure, 1939

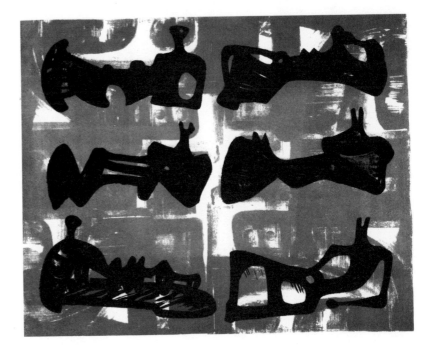

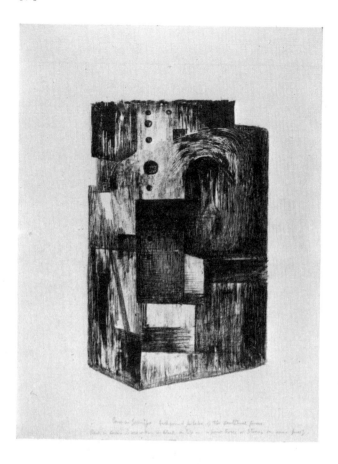

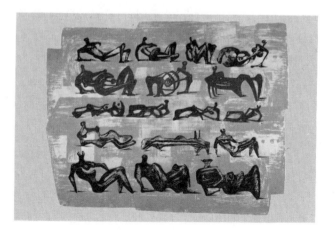

14 Square Forms and Reclining Figures 1963

The first print made in this sequence of lithographs from Curwen Studio in 1963, was a brightly coloured proof in red, yellow, black and grey, drawn direct on the stone (a). The figures relate to the forms for metal sculpture which the artist began making in the 1930s, one of which is illustrated.

Moore also created two architectural forms which relate very closely to the *Square Form* sculptures such as that of 1936 loaned to the Tate Gallery by Sir Robert and Lady Sainsbury. These forms, remembered in the *Time/Life* screen, and as try-outs for the UNESCO commission backgrounds, again emerge primarily as settings in this lithographic series.

One of the forms, printed twice on one sheet (d) was editioned as a separate image. Otherwise both the architectural forms were overprinted in a number of combinations as backgrounds.

The *Square Form* background found its way, overprinted twice in pale grey, into a print to which no less than seventeen reclining figures were later introduced (f), the artist letting light into the central area by working on the stone with nitric acid then deftly siting the figures to their best advantage. In another combination a swirling movement suggested flowing water (e). With two central figures, again from proof (a) superimposed, it became a river background, the reclining figures keyed into their setting in dark olive green against a grey-green greasy Limpopo colour.

Meantime, the silhouettes of all six figures from the earliest proof in the sequence were printed boldly in black on a second of the two background forms Moore had designed for the purpose (b).

Of the recurrence of the reclining figure in his work Moore said: 'If there were a dictator in the painting and sculpture world (like Hitler in the political world) who said: "From now on, Henry Moore, you can't do anything but interior/exterior ideas", I wouldn't worry. I could make it last, it could go on. But if he said: "You must do nothing but reclining figures". Again, everything is in it! Or: "Nothing but mother and child ideas". Again... There are three or four ideas like that, and the reclining figure is one of them ... I can find a reclining figure in everything'.

opposite page
top: lithographic trial proof
bottom: *Seventeen Reclining Figures with Architectural Background*

this page
top: *Square Forms*
bottom: *Two Reclining Figures with River Background*

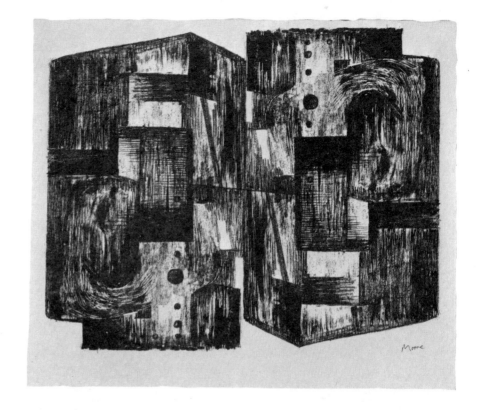

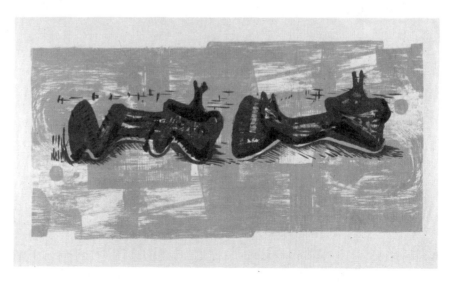

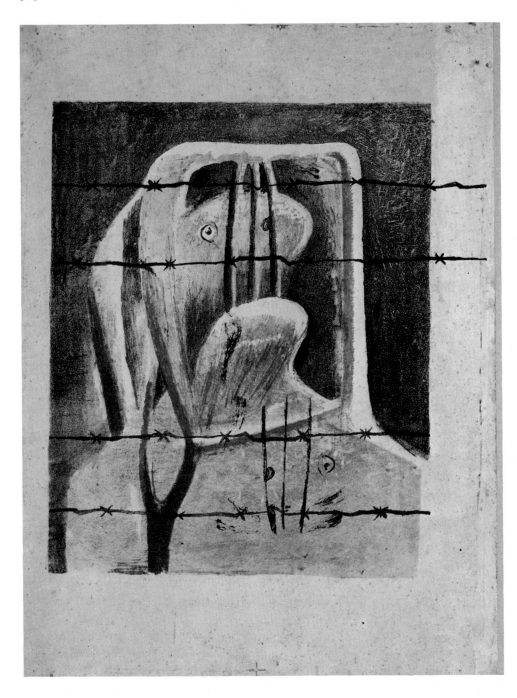

left: Spanish Prisoner

16 SPANISH PRISONER 1939 and HELMET HEADS 1975

'It's the same thing – the eye half hidden' said Moore comparing his first lithograph the *Spanish Prisoner* of 1939 with his most recently published and most colourful lithographic portfolio, *Helmet Heads*.

The concept behind the earlier print, produced partly to raise money for Spanish Republican soldiers imprisoned in France, was that of an organically caged head-form seen behind barbed wire. Because of the war, it was never editioned and only a couple of variant proofs exist. Moore cannot now remember where, or with whose help, he made the lithograph, but he did draw direct on stone, which taught him the principle. He remembers with some distaste, the way the image had to be reversed, the way colour lithography entailed a key image in accord with which every supporting colour had to be somewhat mechanically traced; he also disliked the medium's inescapable granularity. Although he has warmed a little to lithography since, by way of the recent *Stonehenge* portfolio, a British Museum catalogue disclosed that he preferred etching: 'The actual technical, physical, using of the very fine point on metal is to me nicer, or at least, I enjoy it a little more, than I do soft chalk on stone'.

The lithographic image preceded the first *Helmet Head* of 1939/40 which led to the full length internal/external forms that Henry Moore regards as one of his obsessive themes. 'One form inside another, so you get the mystery of not entirely knowing the form inside … it's rather like armour which protects – the outer shell protecting the softer inside – which is what shells do in animals too'. The Tate owns a bronze cast of a later variation, *Helmet Head No.1* of 1950, which demonstrates the way in which drawings (or here, a lithograph) of the 1930s frequently generated ideas for subsequent sculpture.

The recent portfolio of *Helmet Heads* has a less tragic note than the *Spanish Prisoner*, but is still based on the idea of a protected form – a sentinel behind a barricade. It started with an unsatisfactory drawing. 'Technically it got muddied' says Moore. 'It was worked on too much. I made too many changes and alterations so the quality and handling of it was dead. I tore it into about six or eight pieces and threw it on the studio floor. Then I noticed one of the pieces had just one eye on it and it looked up at me with an expression it had not had originally.... And it seemed to me, that once a part of a drawing or a mark on a piece of paper represents an eye – that becomes a focus, as with the human face. So then I began to play with them and stuck them as collage in a notebook, and thought it would be amusing to do a series with one eye rather fierce, a bit mad … another thoughtful … this kind of thing'.

Printed at the Royal College, the suite developed through proofing with the help of collage, and one image, the *Direct Eye*, took as a colour guide a scrap from the invitation to the recent Turner exhibition, jointly organised by the Tate Gallery and the Royal Academy. It's not the first time a reproduction of another artist's work has found its way into a Moore print – a sliver of a Rothko was used to indicate a particular red for the 1973 lithograph *Reclining Figure with Red Stripes*. Of Turner Moore has said: 'He did something that nobody else did until his time and that no one else has done since. People may think that he influenced Monet and the Impressionists, but his was a different way. They did it by light falling on a solid object. For Monet, doing his series of haystacks in the morning, and at different hours of the day, it was the object being changed by light that he was thinking about. But Turner painted real space for the first time. Space that has almost the solid quality that a fog can have, that smoke can have. And his space is really three-dimensional space. He makes a flat canvas have all the space of miles in it.... For me as a sculptor, three-dimensional space, whether it is made of solid stone, or it is made of cloud, or it is made of distance between a few things, it is form. And form and space are one'.

this page
right: *Helmet Head No. 1*, 1950
below left: *Wild Eye*, lithograph from *Helmet Heads*
below right: sketchbook collage

opposite page: Direct Eye, lithograph from *Helmet Heads*

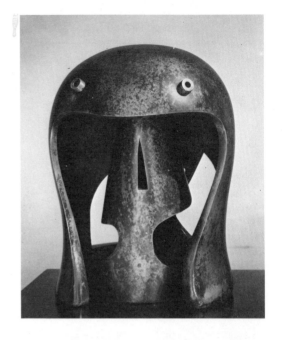

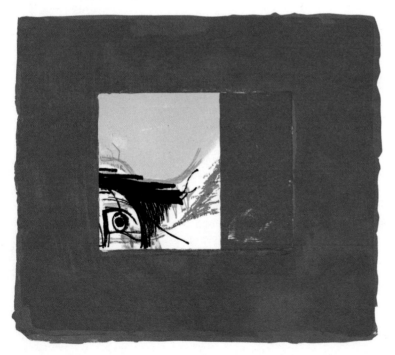

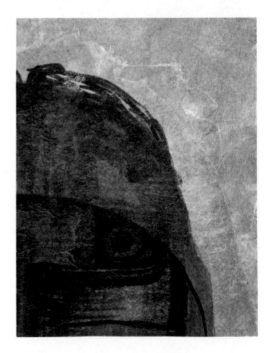

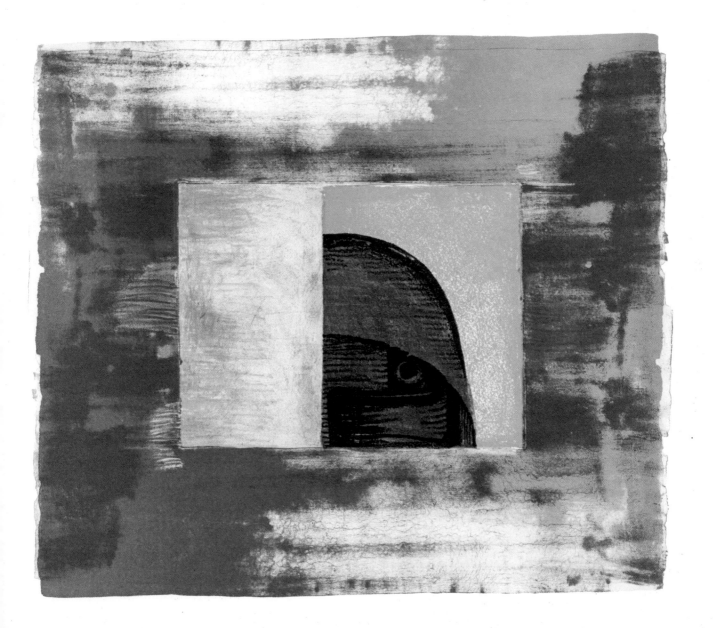

Catalogue

Where a print appears in the Catalogue Raisonné, *Henry Moore Graphic Work 1931–72* (Cramer, Grant, Mitchinson) its catalogue number is cited. Where an uncatalogued trial proof or a print later than 1972 is included, greater detail is given.
[L] indicates on loan from the artist.
[G] indicates that the print is part of the gift of final states donated by the artist to the Tate Gallery in March 1975.

ETCHINGS

1 TURNING FIGURES 1971

a Drawing, *Pen Exercise No. XIV*, 1970 and 1971, pen and wash [L]
b top: Etching in black of *Turning Figures Nos. 1 and 2* drawn on one plate, hand coloured in ink and crayon, the left-hand side using 'a' which reverses in the process [L]
 bottom: Etched colour plate added to black printing [L]
c *Turning Figure No. 1*, 1971, two-colour etching (Cat.175) [G]
d *Turning Figure No. 2*, 1971, two-colour etching (Cat.176) [G]

2 TWO TALL FIGURES, MAN AND WOMAN 1970 and 1971

a Drawing, *Pen Exercise No. X*, 1970, pen [L]
b left: First state, touched by pen at base right: second state, printed with surface ink and rétroussage [L]
c left: Colour plate added in brown [L]
 right: Trial proof of both plates in black and grey [L]
d *Two Tall Figures, Man and Woman*, two-colour etching, 1970 and 1971 (Cat.179) [G]

3 ARCHITECTURE 1971

left: Soft ground etching, first state [L]
right: *Architecture*, 1971, third and final state with drypoint added (Cat.169) [G]

4 ELEPHANT SKULL 1969

top: Etching, first state [L]
bottom: *Elephant Skull Album, Plate VIII*, 1969, etching, fourth and final state (Cat.121) [G]

5 RECLINING FIGURES 1970 and 1972

a Etching, first state [L]
b left: First state, retouched with chalk, pen and wash [L]
 right: realised in the etching of the third state [L]
c left: Fourth state, with some aquatint added, retouched with chalk, pen and wash [L]
 right: Fifth and final state with more aquatint, retouched with pen and wash
d Fifth and final state, plate cut into three to create: top: *Reclining Figure I*, 1970 and 1971 (Cat. 192) [G]; centre: *Reclining Figure II*, 1970 and 1972 (Cat. 193) [G]; bottom: *Reclining Figure III*, 1970 and 1972 (Cat. 194) [G]

6 RECLINING FIGURE 1951, 1962 and 1966

top: Aquatint and dry point – first state [L]
centre: First state, retouched with pen [L]
bottom: *Reclining Figure*, 1951, 1962 and 1966, final state reworked with drypoint and burnisher (Cat.55) [G]

7 SIX SCULPTURE MOTIVES 1970 and RECLINING FIGURES 1972

a *Six Sculpture Motives*, 1970 from *5 Incisioni di Moore*, 1970. Etched forms on lithographic ground, based on 'b' (Cat.164) [G]
b top: First state etching of *Two Reclining Figures* and *Reclining Figure IV* (reverse of imagery used in 'a') [L]
 bottom: *Ideas for Sculpture*, 1970, pen, chalk and wash drawing from which this group originates. Drawing worked both vertically and horizontally [L]
c top: First state heavily worked with pen, chalk and wash
 bottom: realised by etching in the second state [L]
d top: Second state retouched with pen [L]
 bottom: Final state, plate then cut to produce two etchings 'e' and 'f' [L]
e *Two Reclining Figures*, etching, 1970 and 1972 (Cat.204) [G]
f *Reclining Figure IV*, etching, 1970 and 1972 (Cat.195) [G]

8 SEATED MOTHER AND CHILD 1951 and 1966

a top: First state etching with surface tone and aquatint [L]
bottom: First state, reworked with pen [L]

b *Seated Mother and Child*, 1951 and 1966, plate polished, burnished and reworked with drypoint (Cat.78) [L]

9 TWO SEATED FIGURES 1970 and 1971

a Drawing, *Seated Woman*, 1970, pen and orange wash [L]

b top: First state etching [L]
bottom: First state retouched with rust ink, black ink and chalk [L]

c *Two Seated Figures*, 1970 and 1971, third and final state realised on two plates following aquatint and burnishing (Cat.177) [G]

LITHOGRAPHS AND COLLOGRAPHS

10 STANDING FIGURES 1949

a top: Transparent colour separation
bottom: Yellow proof from trial printing [L]

b *Four Standing Figures*, pen and wash drawing used as quarter of 'c' [L]

c *Standing Figures*, 1949, collograph (Cat.9) [G]

11 WOMAN HOLDING CAT 1949

Woman Holding Cat, 1949, collograph in four colours with instructions to printer by artist, and hand colouring (Cat.10) [L]

12 TWO STANDING FIGURES WITH STUDIES ON THE LEFT c.1950

a Two of three colour separations by the artist using pen, pencil and wash over wax resist
top: for yellow or sea green printing
bottom: for black or dark red printing [L]

b top: Proof in green, brown and red
bottom: Proof in green, brown and black with crayon and wash additions (Cat.17) [L]

c top: Proof in yellow, red and black with blue crayon and wash additions [G]
bottom: Proof in yellow, brown and red with blue crayon additions (Cat.17) [L]

13 FOUR RECLINING FIGURES 1974

a Sketch book idea for one figure [L]

b Wash drawing on Kodatrace for 'c' and 'd' in Indian and lithographic ink for light transfer to aluminium plate

c *Four Reclining Figures*, 1974, lithograph in 5 colours, image 17¾ × 23½ in, published by the artist [G]

d *Four Reclining Figures: Caves*, 1974, lithograph in 7 colours, image 17¾ × 23½ in, published by The Art Gallery of Ontario, Toronto [G]

14 SQUARE FORMS and RECLINING FIGURES 1963

a Lithographic trial proof in red, yellow, black and grey, with red and grey wash additions. Yellow printing used for 'b'. Two central figures used for 'e'. Inscribed: 'Try in entirely different colours, e.g. yellow=dk. grey; red=blue; grey=dark red'. Image 19¾ × 26 in

b *Six Reclining Figures with Buff Background*, lithograph, 1963. Figures from 'a' (Cat.50)

c Lithographic trial proof of background stone used in 'e' and 'f'. Retouched with black pastel. Image used twice, once inverted for 'd'. Inscribed: 'print in green? for background perhaps of two sculptural forms, print in brown or red and then in black on top, or print twice or three times on the same proof'. Image 18 × 11½ in

d *Square forms*, lithograph on Japanese nacré, 1963 (Cat.51)

e *Two Reclining Figures with River Background*, lithograph, 1963. Background uses 'c' printed twice widthways and trimmed, two figures come from 'a' (Cat.52)

f *Seventeen Reclining Figures with Architectural Background*, lithograph, 1963. Background uses 'c' overprinted twice (Cat.47)
(All six prints from Curwen Studio Archive Gift)

15 EIGHT RECLINING FIGURES ON ROCK BACKGROUND 1963

a Background image 1963, lithographic trial proof retouched in black

b *Eight Reclining Figures on Rock Background*, 1963, lithograph (Cat.43)
(Both prints from Curwen Studio Archive Gift)

16 SPANISH PRISONER 1939
and HELMET HEADS 1975

a *Spanish Prisoner*, c.1939, lithograph (Cat.3) [L]

b Sketchbook 1974 with preparatory collaged drawing for *Helmet Head* portfolio [L]

c *Helmet Heads*
top: working proof for 'g' *Direct Eye* using collage from Turner reproduction [L]
bottom: trial proof for 'd' *Contemplative Eye* [L]

d-h *Helmet Heads*, final states:
'd' *Contemplative Eye*, 'e' *Superior Eye*, 'f' *Hiding Eye*, 'g' *Direct Eye*, 'h' *Wild Eye*
Lithographic suite using from 8–11 colours, each sheet size 19½ × 25 in, published by Gerald Cramer [G]

17 FIGURES IN SETTINGS 1949

a Trial proof with blue replaced by brown in final print (Ganymed gift)

b *Figures in Settings*, 1949, collograph (Cat.5) [G]

18 SCULPTURAL OBJECTS 1949

a Transparency for red printing on 'c' (School Prints gift)

b Transparency for blue printing on 'c' (School Prints gift)

c *Sculptural Objects*, 1949, lithograph (Cat.7) (P. Seale gift)

RELATED SCULPTURE

IN CASES

Reclining Figure, 1939
Bronze, 5⅜ × 10 × 3⅜in
Tate Gallery T.387

Two maquettes from
Madonna and Child project, 1943
Bronze, 5⅜ × 6⅛in
Tate Gallery 5601 & 2

ON PLINTHS

Half Figure, 1932
Armenian marble, 27 × 15 × 11 in
Tate Gallery T.241

Girl, 1931
Ancaster Stone, 29 × 14½ × 10¾ in
Tate Gallery 6078

Upright Form (Knife Edge) 1966
Rosa Aurora marble, 23½ × 22¼ × 9½ in
Tate Gallery T.1172

Helmet Head No.1, 1950
Bronze, 13 × 10¼ × 10 in
Tate Gallery T.388

Recumbent Figure, 1938
Green Hornton Stone, 35 × 52½ × 29 in
Tate Gallery 5387

Composition, 1932
African Wonderstone, 17½ × 18 × 11¾ in
Tate Gallery T.385

Square Form, 1936
Green Hornton Stone, 15 × 15 × 9 in
Lent by Sir Robert and Lady Sainsbury

Bibliography

Arts Council of Great Britain: *Henry Moore*, prepared by David Sylvester, Tate Gallery, London, 1968

Arts Council of Great Britain: *Sculpture & Drawing by Henry Moore*, prepared by David Sylvester, Tate Gallery, London, 1951

British Museum: *Auden poems, Moore lithographs*, preface by John Gere, essay by John Russell and notes by the artist, London, 1974

Clark, Kenneth: *Henry Moore Drawings*, London, Thames & Hudson, 1974

Cramer, Gerald: *Elephant Skull Original Etchings*, essay by Alistair Grant, Geneva, 1970.

Cramer, Gerald; Grant, Alistair; Mitchinson, David: *Henry Moore – Catalogue of Graphic Work 1931–72*, Geneva, Gerald Cramer, 1973 (Vol.II in preparation)

Fischer Fine Art: *The Complete Graphic Work 1931–72*, essay by R. Melville, London, 1973

Fischer Fine Art: *Graphic Work 1972–74*, including artist on aspects of his graphic art, London, 1974

Forte di Belvedere retrospective catalogue, Florence, 1972

Ganymed: *Stonehenge*, with essay by Stephen Spender, London, 1974

Grohmann, Will: *The Art of Henry Moore*, London, Thames & Hudson, 1960

Hall, Donald: *Henry Moore: Life & Work of a Great Sculptor*, London, Victor Gollancz Ltd., 1966

Hedgecoe, John: *Henry Moore: Photographs at work*, with running commentary by the artist, London, Thomas Nelson, 1968

Henry Moore on Sculpture, ed. Philip James, London, Macdonald & Co. Ltd, 1966

Marlborough Fine Art: *Henry Moore Stone and Wood Carvings* by John Russell, London, 1961

Marlborough Fine Art: *Henry Moore: Carvings, 1923–66*, Introduction by Robert Melville, London, 1967

Mitchinson, David: *Henry Moore, Unpublished Drawings*, Turin, Edizioni d'Arte Fratelli Pozzo, 1971

Museum of Modern Art: *Henry Moore*, by James Johnson Sweeney, New York, 1946

Neumann, Erich: *The Archetypal World of Henry Moore*, New York, Pantheon Books, 1959. Translated by R. F. C. Hull

Read, Herbert: *Henry Moore: A study of his life and work*, London, Thames & Hudson, 1965

Read, Herbert: *Henry Moore: Sculptor*, London, A. Zwemmer, 1934

Read, Herbert: *Henry Moore, Sculpture & Drawings*, Vol.I (1921–48) ed. David Sylvester, Vol.II (1949–54) cat. by Alan Bowness, Vol.III (1955–64) ed. Alan Bowness, London, Lund Humphries

Rijksmuseum Kröller-Müller and Museum Boymans–van-Beuningen: *70 years of Henry Moore*, pictorial biography, ed. David Mitchinson, Netherlands, 1968. (Also at Düsseldorf, Baden Baden, Bielefeld, Darmstadt, 1969)

Russell, John: *Henry Moore*, London, Allen Lane, The Penguin Press, 1968